Robert Frank Thank You

49 Earl Ave
Northport NY

THIS SIDE OF CARD IS FOR ADDRESS

MR ROBERT FRANK

NORTHPORT
JA 9 5 PM 1960

Dear Robert—
That photo you sent me
of a guy looking over his
cow on the Platte River
is to me a photo of a
man recognizing his own
mind's essence, no matter
what——— Jean toncopain

3

fire

love,
Violet ~

{ Robert Frank
" Marthas "
vineyard ~
West Tisbury
Massachusetts ~

THAT FIRE CAN TRULY LIGHT THE WORLD
ITZGERALD KENNEDY · 19

Dear Robert,
blah, blah, blah
No time to think
My mind is totally fucked
How is yours?

——————————————
Stay strong

Sylvain

Robert Frank
R.R. 3
Mabou Mines
Nova Scotia

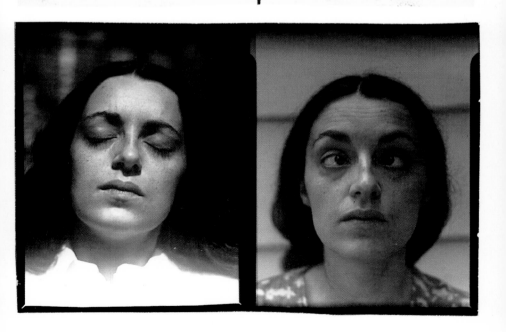

HISACHIYO
MASAKI (17 years old)
NAOKI (16 years old)
KAZUHIKO

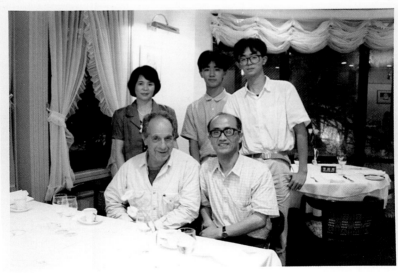

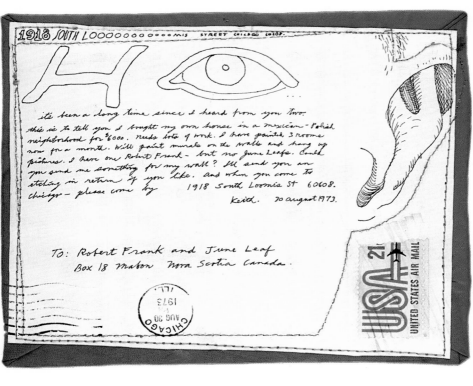

1918 SOUTH LOOOOOOOOOOOOOmis STREET CHICAGO 60608

it's been a long time since I heard from you two.
this is to tell you I bought my own house in a mexican - Polish
neighborhood for $6000. needs lots of work. I have painted 3 rooms
now for a month. Will paint murals on the walls and hang up
pictures. I have one Robert Frank - but no June Leaf. Could
you send me something for my wall? I'll send you an
etching in return if you like. and when you come to
chicago - please come by 1918 South Loomis St 60608
 Keith. 30 august 1973.

To: Robert Frank and June Leaf
 Box 18 Mabou Nova Scotia Canada.

CHICAGO
AUG 30
1973
ILL.

USA 21 UNITED STATES AIR MAIL

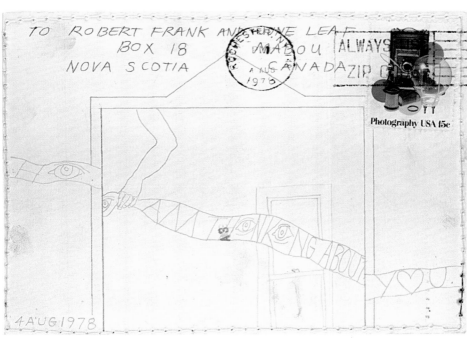

TO ROBERT FRANK AND JUNE LEAF
 BOX 18 MABOU ALWAYS
 NOVA SCOTIA CANADA ZIP

ROCHESTER
AUG
1978

Photography USA 15c

4 AUG 1978

Photo Par Robert Hébert

'Y

ce

can

but only if you waht to

I have been thinking that maybe

you could act act someone else

Tell me if you don't think

you could.

ROBERT —
IM ON THE ROAD
MAY 20 — A.M.
GARY

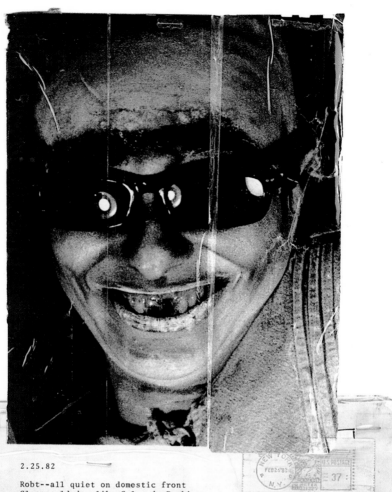

2.25.82

Robt--all quiet on domestic front
Clean cold day like Colorado Rockies
...old self looms. Been transcribing
nonstop uptown biohazards, anthrax
bombs, endangered species, zionist
butchers, Reagan cuts, lava land scams,
Mexican arthritis clinics--Ears itch,
wax pops, money screws down drain
counterclockwise. Clockwise in southern
hemisphere I think. Same drain. Cheers.
Brian goes north now, eh? Scottish guy
on one tape yesterday--short, curt,
unworried about bloated sheep washing
up on the beach from an island where
government is doing chemical warfare
research...sounded like the man with
three names showed up that morning we
were in the hole with purple potatoes
in his cap...

Robert Frank
Mabou
Inverness County
Nova Scotia
Canada

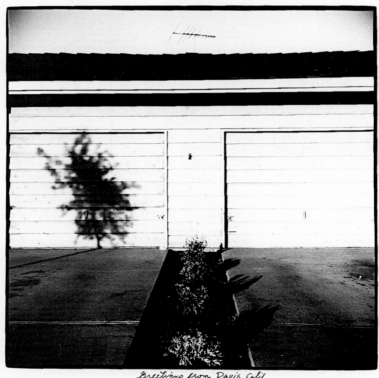

Greetings from Davis, Calif

R O B E R T

I have been here at Halifax since May and am going to **finish** hin Dec.
A back tract of background that taunts me with these kind of THINGS THAT MU~
st be done. BUT **TIME**. It becomes essential to trust t i m e / time to
sort out the substance from mirages/fat/time that makes things clearer. I lost
or at Photographs made a big leap, an ever widening or suddenly wi unbreachable
spiral that shot from my fingertips . I don't know if the photographs are kites
still attached to by a thin string to me Or if they that will bring them
reeling back agin. THERE IS TOO MUCH information/ and illusive images dart around
Nothing will stand in line.

I am trying to untangle a bit and allow the images and things to suggest their
own vocabulary.

I hope all your ilness is out/ and your

 katherine knight(duck I) (duck two is in London Ontario for the
 the winter/we are maybe oiling our feathers)

Pablo says you
should keep a

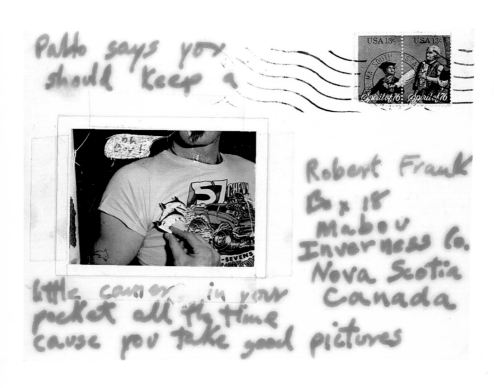

Robert Frank
Box 18
Mabou
Inverness Co.
Nova Scotia
Canada

little camera in your
pocket all the time
cause you take good pictures

To Robert — no words yet!

Barak

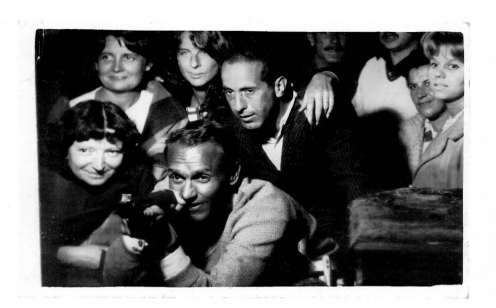

Memo from the Moon:

For Robert —
half moon & a small plane
blinking above the trees
flying over the bridge to Daytona Beach.

Allen Ginsberg
June 7, 1987.

FOR
ROBERT AND JUNE. A
WINDOW VIEW. MAY
YOUR DAYS BE PRECIOUS
FROM RH CHRISTMAS 1984

HENRY FRANK-ZUCKER
1890 — 1976
ROSY FRANK-ZUCKER

WENDEN

Lieber Robert liebe June
es waren leider keine 15 Stones
mehr vorhanden. Der Gärtner vom
Friedhof denkt dass Sturm wind den Strauch
wie einen Besen wirken liess. rechts
 Zu deiner Ausstellung in Whashinton
werde ich nach New York kommen,
werde Gartenwerkzeuge mitnehmen
um nach Deinem Baum zu schauen
 Herzlichst Werner

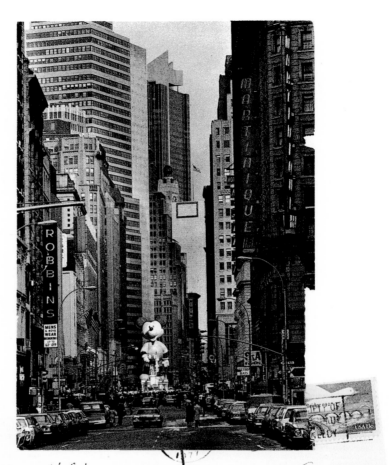

Another Holiday,
Another Parade,
Another Negative
Another Print

Robert Frank
Mabou Mines
Nova Scotia
CANADA

12/12/93 Dear DAD + JUNE

GLAD To HEAR About the New Pep in your Type-
WRITTEr the Wind up Here is STRONG + it Whips AROUND
MY ROOM but the Heat is Good I DREAMPT I WAS

WALKING AROUND LAHASKA AND VANNA White WAS
calling for Me To CATCH up With HER. IVe Been
FARTING ALOT LATLEY SO I HAD four GRilled chesse
SANDWICHES + 2 Bowls of Cereal --- That should change
MY INSIDES MAYbe I'll WATCH The News To-nite
AS it's FRANK SINATRA's Birthday Today. Did you
Know the Docks of The STATUE of Liberty ISLAND
Need 9 million $ worth of WORK on them Hope things
GO Well. TODD RUNGreeNS LATEST Album is called "NO WORLD
ORDER See you JUNE LOVE PABlo

To Robert
November 1991
Fernando
Even if I am falling apart
I am still counting on
my godfather vey!

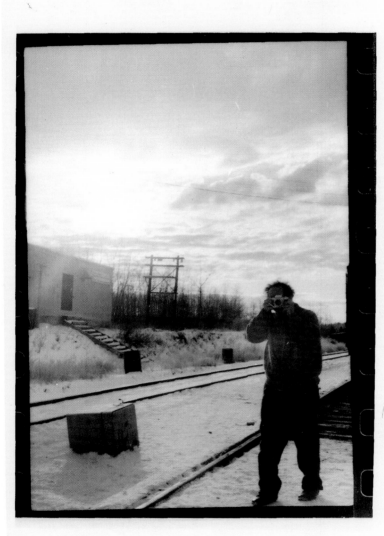

Robert —
shooting
North 1

Pullman —
WAGAN
191

Jet

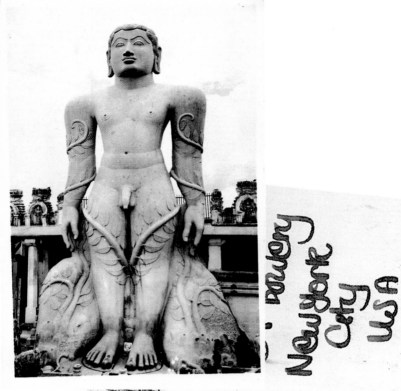

New York
City
USA

AIR MAIL

Mr. Prem and
Mr. Yusuf
join me in
sending regards
Conrad

22

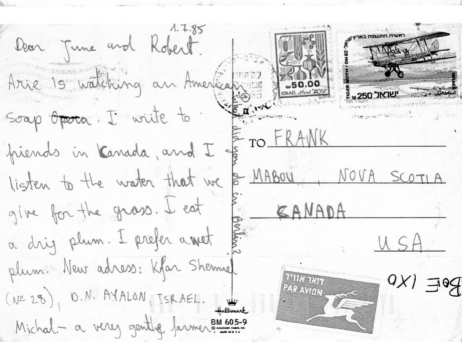

1.7.85

Dear June and Robert.
Arie is watching an American
soap opera. I write to
friends in Kanada, and I
listen to the water that we
give for the grass. I eat
a dry plum. I prefer a wet
plum. New adress: Kfar Shemuel
(№ 28), D.N. AYALON ISRAEL.
Michal — a very gentle farmer

did you do in berlin?

TO FRANK

MABOU , NOVA SCOTIA

KANADA

USA

ℵ50.00 ISRAEL

ℵ250 ISRAEL

PAR AVION

Hallmark
BM 605-9

BoE 1X0

23

Dear Robert Frank; [CARD IS FROM '84] Aug. 15/88

Recently Sophie Hogan, a young photographer, visited me in Holyrood Nfld! She left this card/photo of her friend, addressed to you, behind. I thought I'd forward it. I believe she's been sending you cards.. I'm into that too. I'm a maverick artist turned photographer or a photographer with pretensions to "art" according to which critic you read... MANNIE BUCHHEIT 6 HIGHLAND PARK, HOLYROOD, NFLD. CAN.

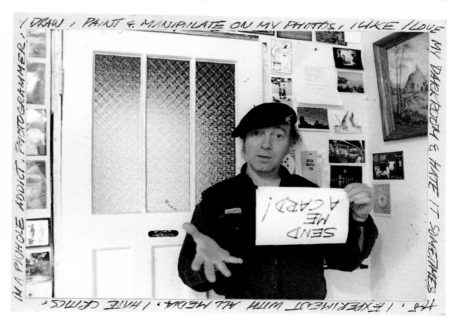

I DRAW, PAINT & MANIPULATE ON MY PHOTOS, ILIKE ILOVE MY DARKROOM & HATE IT SOMETIMES ++ I EXPERIMENT WITH ALL MEDIA, I HATE CRITICS, I'M A PINHOLE ADDICT, PHOTOGRAMMER!

SEND ME A CARD!

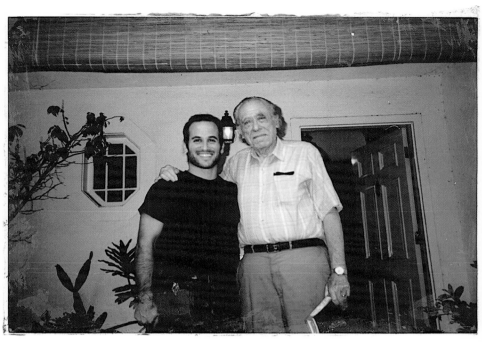

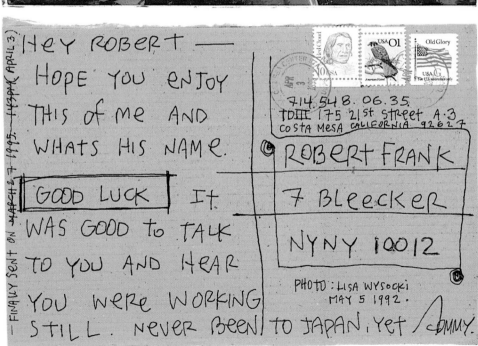

HEY ROBERT —
HOPE YOU ENJOY
THIS OF ME AND
WHATS HIS NAME.

GOOD LUCK IT
WAS GOOD TO TALK
TO YOU AND HEAR
YOU WERE WORKING
STILL. NEVER BEEN TO JAPAN, YET. TOMMY.

— FINALY SENT ON MARCH 7, 1995. (11:30PM APRIL 3.)

714. 548. 06. 35.
TOIII 175 21st street A·3
COSTA MESA CALIFORNIA 92627

ROBERT FRANK

7 BLEECKER

NYNY 10012

PHOTO: LISA WYSOCKI
MAY 5 1992.

25

My wife stopped LIKING me when I picked up a camera 6 years ago. At first she said I loved my camera more than her. Now it's more like a total disdain for me (the new me) and what I do. We have two beautiful children & that alone is what spins it all together.

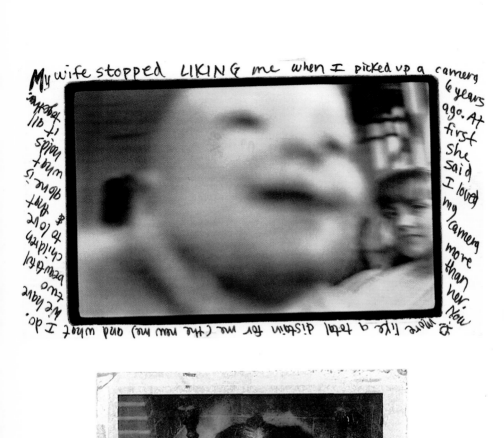

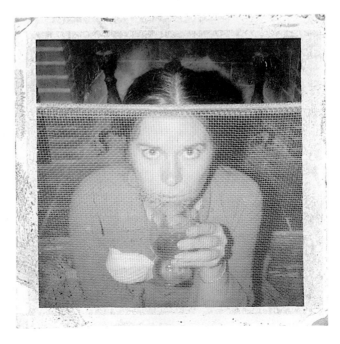

2-17-75

Robert —

I'm still kicking around
Paradise, here in Davis. Winter
was cancelled and it appears
the good lord has the same
fate in mind for spring.
I prefer Halloween.
I'm still looking for a
teaching job. I'd be
grateful if you would
pass ...

Postcard

Mic
613
Dav

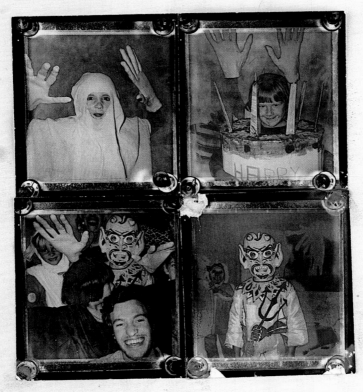

VAN NUYS CA 914 28
PM
28 DEC
1987

Dear Mr. Frank,
 I can't help myself:
as I become more familar
with your work and your
biography, I feel close.
 Happy Holidays to
you + your Loved ones.

Franklin

FRANKLIN ODEL
25000 Hawkbryn #17
Newhall, CA 91321
 (805) 254-6686

Robert Frank
P.O. Box 18
Mabou, Nova Scotia
 Canada

14¢
Julia Ward Howe

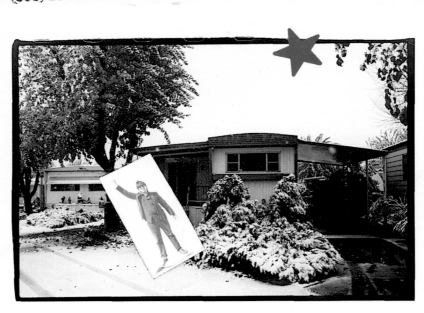

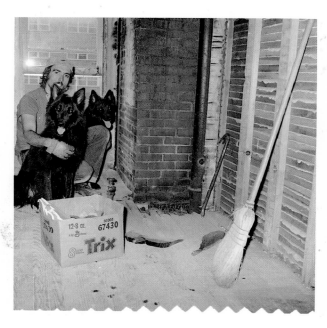

Robert,
I'ue made it to thirty
with out working.

I'ue been tearing
out the walls
and running with the dogs

How has Nova Scotia
treated you?

Lou

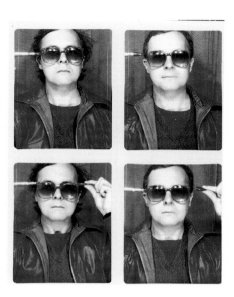

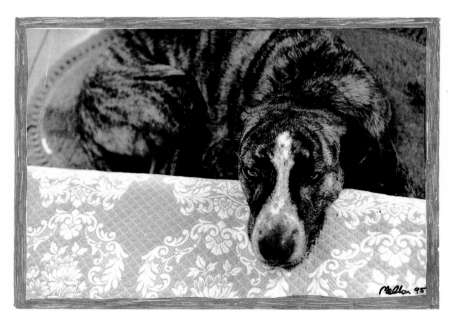

twelfth of august 74 in new york
Dear ⟶

 The other day as I was lookin over my
shoulder
who should I see but my old friend,
Deja Vu. (You remember ol' Deja - he
used to follow YOU around too)
 So we both said Hi and went someplace
to talk over old times and the re-
petitiveness of all things. We had some
drinks and repeated the necessity
for preparedness. Deja said the distance
from there to here is different
from that from here to there.
We had a good time that day and then
Deja left, saying he had to attend
a reception. He is as big a liar
as ever,
but an interestin feller
(just the same).

 x Person

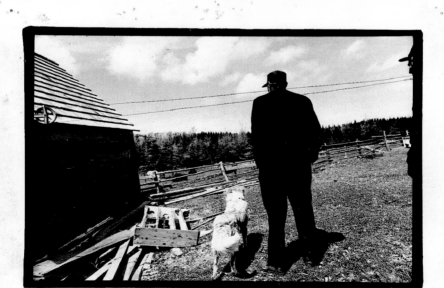

robert — now mo
regardless of the weather
feathers. Its all around
sound.

than ever
vith or without
athing

Robt. 1
 I could never
bring myself to work
with the 4×5 Negatives so
I've sent you the original.

This Machine Cures Cancer

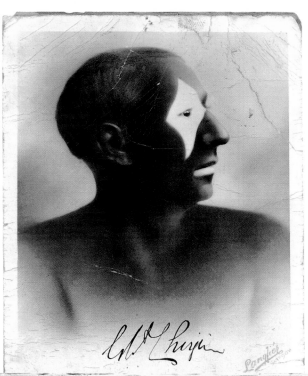

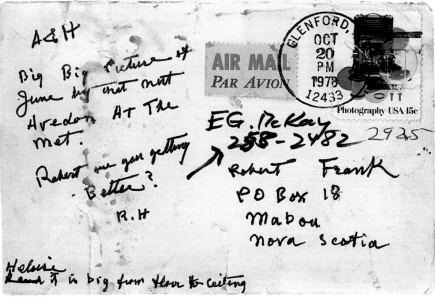

MIAMI FLORIDA 1989
PHOTOGRAPH BY RISAKU SUZUKI

There are so
many Images.

Risaku
Suzuki
4/17 '94 Tokyo

SIR. I DECIDED TO DELIVER THE LETTER
TO DR. SARNER IN PERSON.
DR. S. SAID "HELLO MR. FRANK, YOU LOOK
ODD." I SAID "I AM, I AM IN FLUX"
DR. S. SAID "YOU'RE IN FLUX" I SAID "YES,
MEDICALLY SPEAKING, MY CONDITION REMAINS IN FLUX"
DR. S. SAID. "IS IT PAINFUL, MEDICALLY SPEAKING...
THIS FLUX THING I MEAN. TO GO UP AND DOWN,
CONSTANTLY. ENDLESSLY SHIFTING YOUR FEET."
JOHN CAGE SAID. "EVERY NOW AND THEN IT IS
POSSIBLE TO HAVE ABSOLUTELY NOTHING".
E.M. CIORAN SAID " THE MYSTIC IN MOST
CASES INVENTS HIS ADVERSARIES. IT IS
A STRATEGY OR NO CONSEQUENCE. HIS
THOUGHT BOILS DOWN TO A POLEMIC
WITH HIMSELF."
GENERAL EISENHOWER SAID.
"IS IT PAINFUL."
I SAID. "YES"

JUST REALIZED
LEFT MEXICO. YOU HATE

SEE FILM "HUNGER" FANTASTIC

U.S. POSTAGE
5c

EL ROBERTO FRANCO
PUERTO. MARQUES
ACAPULCO
MEXICO

37

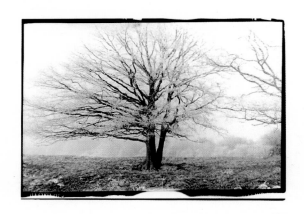

STILL ALIVE,
STILL LOOKING AT THE TREES,
STILL LOOKING FORWARD TO SEE YOU,

HOW IS LIVE FOR BOTH OF YOU ?
I'LL TRY TO BE IN NEW-YORK ONCE MORE...

I HOPE EVERYTHING'S NICE FOR YOU
 BEST WISHES FROM DOMINIQUE, AND
MILENA (4 YEAROLD NOW)

 JE PENSE À VOUS ET JE VOUS
REDIS MON AMITIÉ

 Pia

 Dominique.

3/21/85

Dear Robert -
Special
Deep
True
Robert
I wish I had had more time.
Some of your pictures live
inside my heart + brain.

Sincerely

PS - Thanks for
"up you go little
smoke".

- Alexandra Avakian

BURNED T.V. : MARLETON HOTEL SERIES

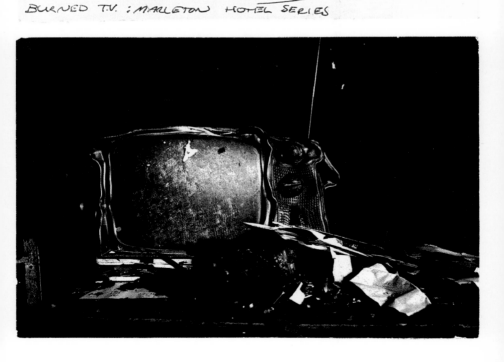

40

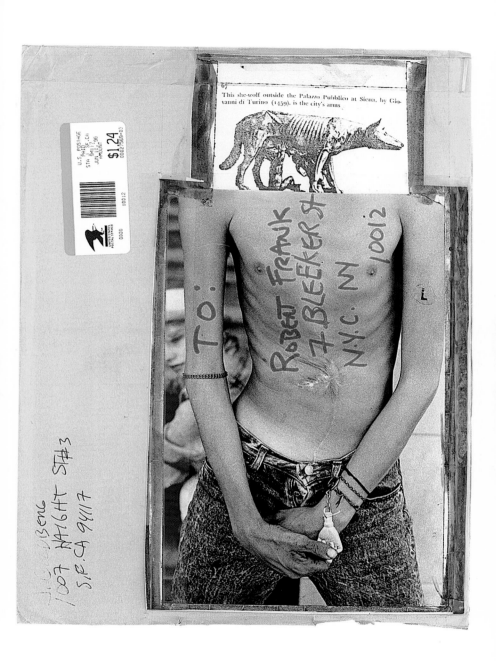

Robert:
Just back from
a thousand visions,
visitations and
travelling at the
speed of sound
in Europe with
Watkins film. I saw
... in Montreal.

Robert Frank
c/o MABOU COAL MINES
CAPE BRETON

ГОСПОЖА ТУНДРА
FRAU TUNDRA

Hi Robert : at long last —
lot f interesting
people will
come —
~~it they~~
Hope you well

Will send
you a copy —

We saw Paul
My ~~Dosse~~
Davey
in Naropa
Boulder
last summer
class room
I answered
question —
for
the students.

The Gotham Book Mart
and
City Lights Books

cordially invite you to a reception in honor of

PETER ORLOVSKY

to celebrate the publication of his book

CLEAN ASSHOLE POEMS & SMILING VEGETABLE SONGS
Poems 1957 - 1977

Monday, December 18th, 1978, 5 to 7 pm
GOTHAM BOOK MART GALLERY
41 West 47th Street, New York

Love & Fresh apple Juice To you — Peter Orlovsky

SOÑAR
WHO CAN
OR EVER
COULD...
FLY?

ROBERT
FRANK
RR 3
MABOU
NOVA SCOTIA
CANADA

Nov. 2, 1969

a note of introduction..
John Spence
Lincoln, Nebraska

Robert Frank
203 West 86
Apt. 24
New York
New York

LINCOLN
NOV 3
PM
1968
NEBR.

10¢
AIR MAIL

FIRST MAN ON THE MOON

UNITED STATES

oásis 75 album

To Robert with ♡ and good
and - full life (89)

MR ROBERT FRANK
PO BOX 18
MABOU - INVERNESS
CANADA
see nova scotia

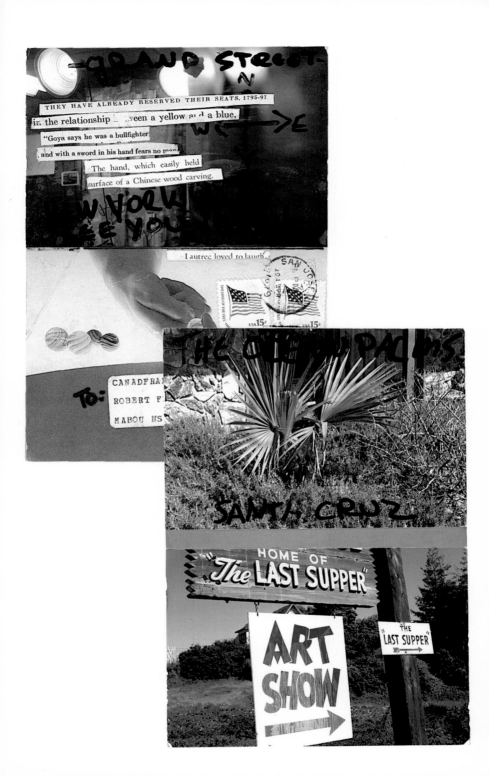

Second Evans Retrospective—Smaller but Powerful

By HILTON KRAMER

Special to The New York Times

NEW HAVEN, Dec. 9—In the annals of photographic art, 1971 is clearly going down as Walker Evans's year. It began in late January, with a large, dazzling retrospective exhibition at the Museum of Modern Art. It is drawing to a close with a smaller but no less dazzling exhibition opening today at the Yale University Art Gallery here? Among this great photographer's other distinctions, he must surely be the only American artist ever to be subjected to the ordeal —and the high compliment —of two retrospective exhibitions in a single year.

The exhibitions overlap, of course, but they are distinctly not the same exhibition. The Modern's big retrospective numbered 200 prints, whereas Yale's smaller show consists of less than half that number. Almost half the pictures at Yale are not included in the Modern's show, which is still circulating around the country. It recently closed in Ann Arbor, Mich., and will next be seen at the Art Institute of Chicago in July. Indeed, at Yale there is a new series of photographs, taken in Nova Scotia a few months ago, which did not exist at the time that the earlier show was organized.

The emphasis, too, is somewhat different. There is a more concentrated focus in the new show on Mr. Evans's interest in hand-lettered signs, printed ephemera, and buck-eye advertising art. His keen interest in this throwaway folk art goes beyond his magnificent use of it as a photographic subject. He has long been an assiduous collector of anonymous signs and discarded printed matter, and for the first time he is exhibiting some of the items from his private collection along with his photographs.

The result is an illuminating juxtaposition of two very different kinds of artistic intelligence: the folk esthetic to be found in popular visual materials, and the highly formalized esthetic intelligence of the photographs based on these materials. In most photographic art, we are aware of a certain tension, or dialectic, obtaining between life (the subject) and art (the photographer's treatment of the subject). Mr. Evans carries the matter a step further in this exhibition, forcing us to consider the relation of one form of art to another. He has in fact sprung a beguiling intellectual trap in this show that estheticians will be extricating themselves from for years to come.

But this canny juxtaposition of art forms is not by any means the only new interest the Yale show offers us. Mr. Evans has also gone back over his earlier, well-known work from the thirties and forties, slipping in some totally unknown prints of subjects already familiar to us. There are some powerful pictures of the American South and of Havana dock workers that will be new even to connoisseurs of Mr. Evans's art—a hint, perhaps, that we are still a long way from having mastered every aspect of his enormous production.

And then there are the new pictures. Several of them—the photographs of old kitchen stoves and coal stoves and furniture and objects in humble Nova Scotia interiors —are as fine as anything in this vein Mr. Evans has ever done. But there is another dimension to these pictures, too —a historical dimension. They include a marvelous portrait of that other extraordinary photographer, Robert Frank, and it was indeed at Mr. Frank's Nova Scotia home that all the new pictures were taken. They thus constitute a chapter of photographic history of special interest to students of the medium.

The Yale exhibition has still a further significance. This is the year Mr. Evans retires from his position as professor of graphic design at Yale. His presence on the faculty of the School of Art and Architecture in recent years has signified the acceptance—if not the celebration—of photography as a high artistic calling by the academic community. Now the Yale University Art Gallery has made this happy alliance official by mounting for the first time a major photographic show. They have started at the top, just as the School of Art and Architecture did in luring Mr. Evans to its faculty in the first place. His is going to be a hard act to follow.

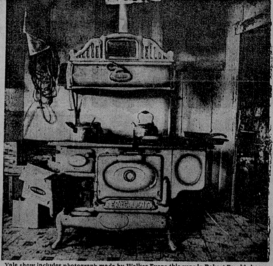

Yale show includes photograph made by Walker Evans this year in Robert Frank's home

"If you don't get them
they'll get you"
Robert Frank

Sammy

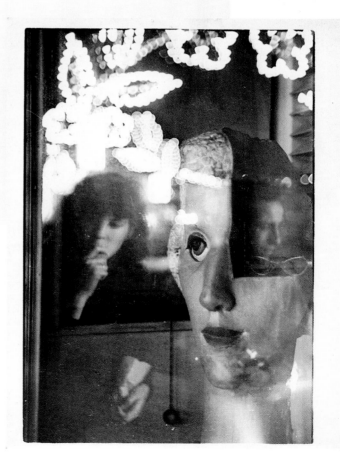

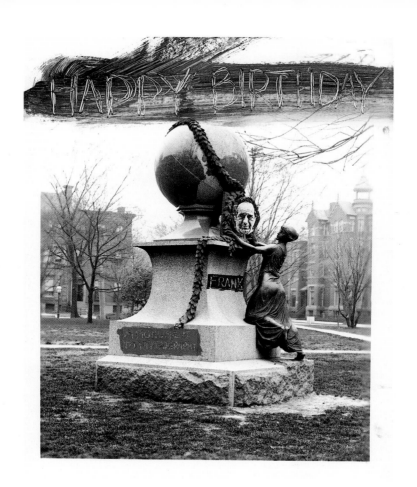

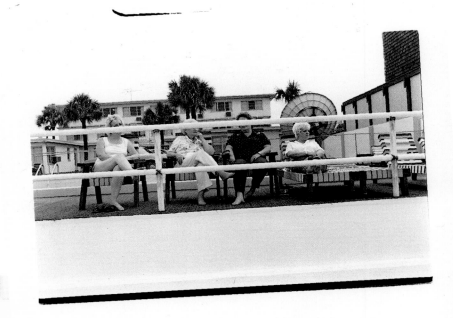

This little scene must look familiar —
Have to say, when I saw that ople you had
filmed there, I was so impressed that I had
to go and see who might be sitting there.
 I just returned from Mardi gras the
other day; what an outrage! Even though
it was quite cold thousands of "Mardi gras"
and some Diane arbus look alikes jammed
the narrow streets of New Orleans. We were
endlessly showered by necklaces of multicolored
beads. Women perched on balconies nonchalantly
showed their "tits" while the boys replied by showing
off their "dicks". Bon bon...
 Just recently saw the announcement of
your upcoming Houston appearance and showing
of "C.I.S. Blues parental discretion advised!" I hope
to make it down. Je vous salue, Alan

Robert Frank
#7 Bleecker St.
New York, N.Y. 10012

Dear Mr. Frank,

Thought I would write to wish you a happy Birthday: So, Happy Birthday; keep busy; and cheerful; best wishes.

There is really no other reason for this letter. Just that.

Greetings from Chgo — Jno Cook

[haven't heard from Delpire, so I sent him a bill a week ago] [Kismeric called.]

[If you're ever in chgo-land, stop in, just walk up the back stairs to the second floor. We'll keep a beer in the icebox for you] [What are you busy with?]

HAPPY BIRTH
DAY TO YOU,
HAPPY BIRTH
DAY TO YOU,
HAPPY BIRTH
DAY TO Robert

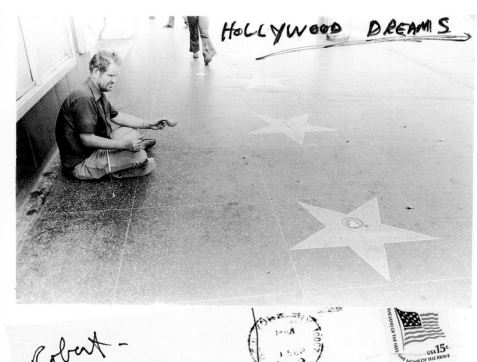

HOLLYWOOD DREAMS →

Robert —
I'm not
even on the line
anymore
on the way up.
Summer's over
see you
Ed

Robert Frank
Box 18
MABOU
N.S.
CANADA

I WAS THINKIN' REAL HARD ABOUT WHAT
I COULD GIVE THIS GENIUS FLIM MAKER
I KNOW FOR A PRESENT..... WHAT COULD
I HAVE DONE BUT GIVE HIM A GENIUS
WORK OF ART ?.... S. W. '78

TO ROBERT FRANK FOR
BEING SUCH A GOOD
NON-TEACHER AFTER
ALL, WHATS A GOOD TEACHER
BUT A NON-TEACHER ?
(SOUNDS LIKE ZEN TA' ME ...)

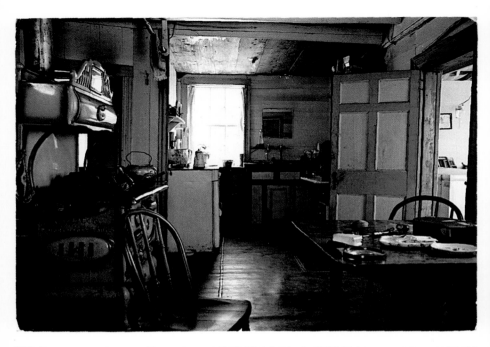

I think of you a lot - here
not summer dep in New York
+ all those grassy hills + I'm
on my way to Maine for
a couple weeks of fresh
air and solitude. Hope
Robert's trip to Switz was
not fraught with "too
much passion" (Always!)
Is there any other way?
The only way to love is
hard (right?) and I do
(if from afar). You should
talk! So be it. love, Chris

JUNE LEAF
ROBERT FRANK
R.R. 3
MABOU
INVERNESS CTY
NOVA SCOTIA
CANADA

Dear Mr. Frank: Hi!
How R u? Thank u very
much for the postcard.
I've been busy w/
school. I will write
in detail next wk
when finals R over.
Hope u are keeping
warm. Cold in Hi! to
(Lady OH, June.
w/
Cancer) Ting-Li
 3/01 96

TL.Wang
320 W.Union
#216
Athens.OH
 45701

Mr.Robert Frank
7 Bleeker St.
NY, NY. 10012

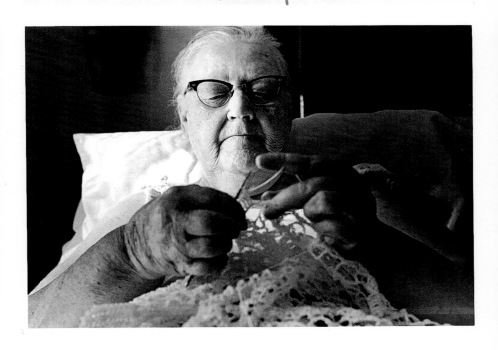

DEAR MR. FRANK ✷✷✷
HOW ARE YOU? I'M FINE.
I FOUND GOOD WAY! GOOD
RELATION OF PHOTOGRAPH
AND WORD... IT IS POSTCARD!!
LITTLE DIFFERENT? OK. I KNOW.
BUT, I WANT, SHOW YOU MY
WORKS. I SHOULDN'T MAKE
FULL WITH MY WORKS IN YOUR
OFFICE. SO, POSTCARD IS GOOD
WAY! IT IS COMFORTABLE. OK?
THANK YOU!! SEE YOU AGAIN.

NAME TOSHI. SINCERELY
HELLO!! YOURS.
GOOD HEALTH? FROM
TOSHIYUKI
UEDA

I'M SORRY FOR SOUNDING SO SELFISH

MR. ROBERT FRANK

7 BLEECKER

NYC 10012

U.S.A.

=AIR MAIL=

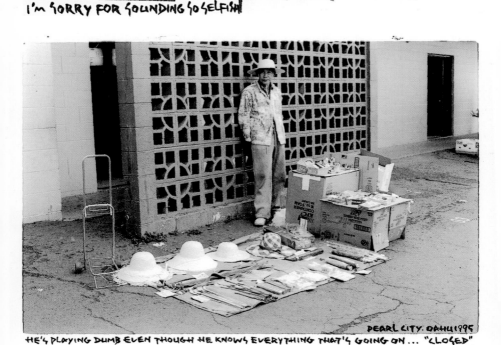

PEARL CITY. OAHU 1995

HE'S PLAYING DUMB EVEN THOUGH HE KNOWS EVERYTHING THAT'S GOING ON ... "CLOSED"

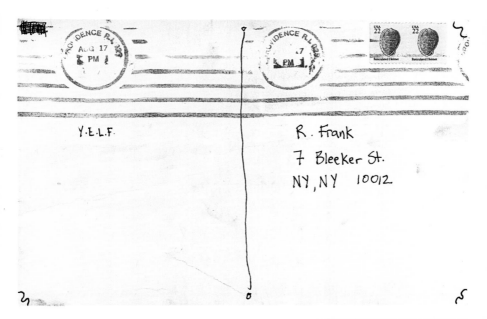

Y.E.L.F.

R. Frank
7 Bleeker St.
NY, NY 10012

PHASE II:

HELLO AGAIN ROBERT.
 SO THERE I WAS AT
THE FOOT OF YOUR ROAD IN
MABOU — MY HEAD WAS
POUNDING FROM THE NIGHT
BEFORE — AND MY MOUTH
SEEMED INCAPEABLE OF
FORMING WORDS — SO I
KEPT DRIVING ... BUT YOUR
NOT OFF THE HOOK YET! I
TOLD BRIAN THAT I MIGHT GO TO
N.Y. IN OCTOBER — AND THEN THERE'S
MABOU SUMMER'89.
 YOUR HOME IS WONDERFUL — I
ENJOYED PROWLING ABOUT.

BOE INO

Sophie.

82 GLEN MANOR DR
TORONTO
M4E 2X2

60

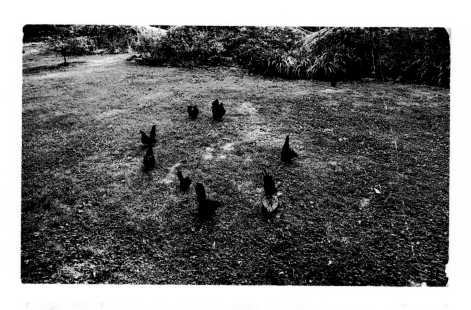

"PICTURE OF
NINE DECEASED CHICKENS,
1972"

ORIGINAL PHOTO POST CARD
MAIL

MADE IN U.S.A.

9c
U.S. AIR MAIL

Kodak
PLACE
STAMP
HERE
Paper

ADDRESS

R.F. & J.L.
BOX 18
MABOU
NNA SCOTIA
CANADA

Robert.......I'm still
"looking out the window".....
Paying hommage to the gift of
perception.

I hope the new year finds you
well, with enthusiasum and hope....
for the stone unturned!

Best to you!

P, Kirchner-Dean
108½ Kinnaird St Camb. 02139

Robert Frank

Mabou

Nova Scotia

CANADA

to beare witness to the light....John

Christmas, 1986

Am hoping the strength/
vision to finish my long
"poem"....bicycling photos....
Best wishes & health to you...
The long, angular winter
light spills from the window...

& I dream of a trailer on
the end of a dirt road...

& rest.

P. Kirchner-Dean
108½ Kinnaird St. Camb. MA 02139

Robert Frank

Mabou
Nova Scotia
CANADA

Sep. 7, '87

Dear Mr. Frank,

PACE / McGILL ギャラリー気付で 7月に あなた あてに 出した 手紙 が,

My letter addressed to you in July with PACE / MaCGILL GALLERY has

夏も終る 今頃に なって 戻ってきて しまいました。

unfortunately returned to me at the time when the summer season

PACE / McGILL は 移転したのですか?

being over. Has PACE / McGILL been moved to another location?

8月はじめ, Jim Goldberg 夫妻が タイに 向かう 途中 東京に 立寄り

At the beginning of August, Mr. and Mrs. Jim Goldberg paid

ました。 急な ことでしたが、一日だけ 通訳を 務めて くれる 知人 がいた

a visit to Tokyo on their way to Thailand. As they visited suddenly,

おかげで 会って 東京をめぐり 歩く ことが できたのは 幸いでした。

I could meet and go through Tokyo with them in help of my friend

who speak English. That was an only one day pleasure, but I fell

satisfied.

私は、今秋 あなたを 日本に お迎えできる と 期待していても よろしいのですか?

Can I expect to welcome you to Japan this autumn?

次回に作りたい あなたの本について、また、あなたの展覧会を 日本で 開催する 可能性

I hope to discuss the plan of publishing your next book and also

について ご相談を したいし、そのことで 杉浦さん にも お会いして いただきたいと

the possibility for holding an exhibition of your works in Japan.

思っております。

and

もし、ご来日の 日取りと 滞在予定日数 が お決まりでしたら、早目に お知らせ

If your itinerary of coming to Japan, your arriving and departure

ください。ご案内する 日本国内の旅行日程を 計画 したり、通訳者を 探したり

have already been decided, please tell me as soon as possible because

しなければ なりませんから。

I have to make up the trip schedule throughout Japan and to

look after an interpreter.

本は、11月の あなたの 誕生日までには 完成できる 予定で 進行して

The book is now under progress in a way that it will be

おります。

completed by your birthday in November, —— I believe ——.

Yours sincerely,

Kazuhiko Motomura

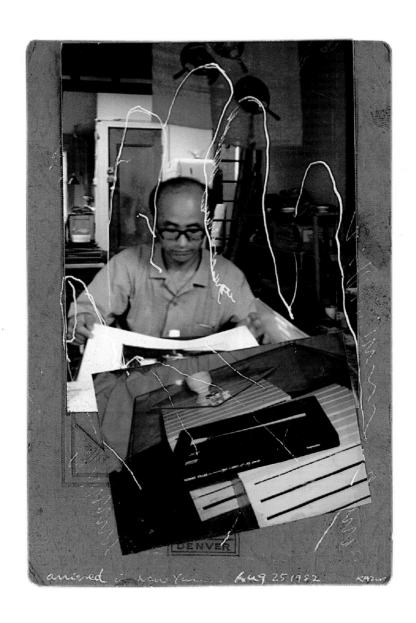

arrived in New York. Aug 25 1982 KAZUO

The Flying Accabonacs!

are cleaning up their act —
Shiela to New York, a journey
to the East — Ralph to old
Mexico, to sit and be and
watch the light — and shoot
albino covers — ~~~~~

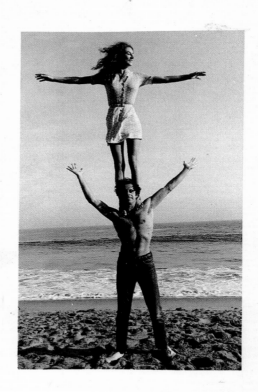

New York, November 17th, 1995.

Dear Mr. Frank:

 We are eight young photographers
from Buenos Aires, Argentina who came to New
York to see your actual exhibition.

 We simply want to make you know
our respect to your work and sense of life.

 And what this, means in our lives.

S. Porter.

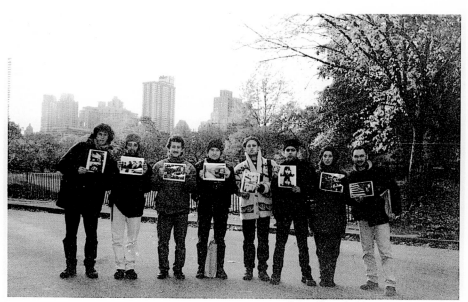

Central Park, New York, November 15th, 95.

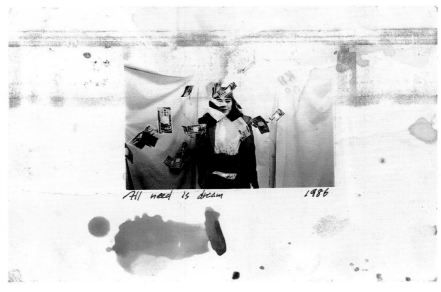

All need is dream 1986

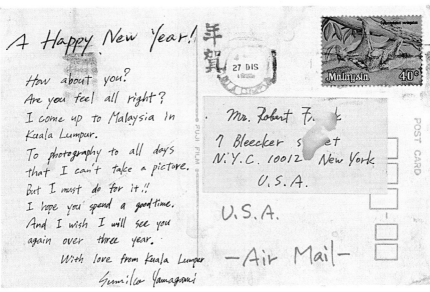

A Happy New Year! 年賀

How about you?
Are you feel all right?
I come up to Malaysia In
Kuala Lumpur.
To photography to all days
that I can't take a picture.
But I must do for it!!
I hope you spend a good time.
And I wish I will see you
again over three year.
 With love from Kuala Lumper
 Sumiko Yamagami

27 DIS

Malaysia 40¢

Mr. Robert F. ...k
7 Bleecker street
N.Y.C. 10012 New York
 U.S.A.

U.S.A.

—Air Mail—

POST CARD

FUJI FILM

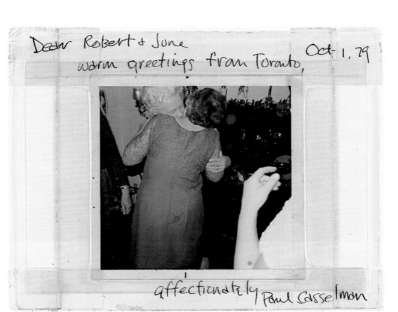

Dear Robert & June
warm greetings from Toronto, Oct. 1, 79

affectionately Paul Casselman

... news.
...per format and has ok B&W reproduction.
What I intend to do unless I hear otherwise from
you is to take the books I have of yrs
& use illustrative material from them as
anything e you could otherwise send might
be too late, though I would like to have
smthg from C.S. Blues, and Keep Busy.
Maybe we can do smthg further with the
material in which case we could use
the pictures that you could send (?)
In any case, hope that your trip south
went well and that this letter finds you
in good spirits, best...

ROBERT FRANK
MABOU
INVERNESS COUNTY

Canada 14

PHOTO POST CARD

Since November 1985 when
you visited my school in
Toronto (York University) I have
intended to send you a
sample of my photography.
In our discussion (at the
reception after the screening)
I said that I thought the
objective point of view
could be just as revealing
as the subjective (autobiographical). Brian Condron

Robert Frank

Mabou,

Nova Scotia

ROBERTO "MANO DE PIEDRA" FRANK

YOU CAN ALWAYS KEEP ON THE

RING, BEING SMART, WHEN THE

PUNCH LACKS THE OLD STRENGTH, THEN

YOU HAVE TO SLIDE THROUGH AND AROUND

, SOMETIMES THEY HAVE TO BELIEVE YOU

ARE INVISIBLE, OR LIKE THE JAPANESE

FIGHTS, USE THE STRENGTH OF THE ENEMY

AGAINST HIM, WHILE YOU KEEP YOURS

INTACT

 BUT NEW YORK, IS A TOO CROWDED

MADISON SQUARE GARDEN

WHAT ABOUT THE MOUNTAINS THE DESERT, THE SEA

 KEEP STRONG . VINCENT

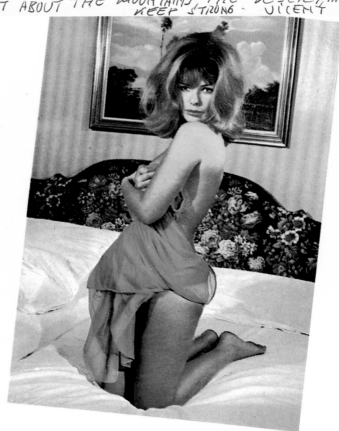

72

Dear Mr. FRANK.
Thank you very much for your hospitality. I was very happy to have met you. Next time I want to you to see my works.
I believe your project will be successful and will be loved just like you.
I'm thinking of going to study New York to English and photographs with Sumiko.
I hope see you again!
 soon
· Respectfully · Risaku Suzuki

7 Bleecker st
NYc 10012

Robert Frank

Air mail

3-22-6 (203)
Nakameguro
meguro ku
Tokyo
Japan

R · S

73

UNITED STATES PENITENTIARY

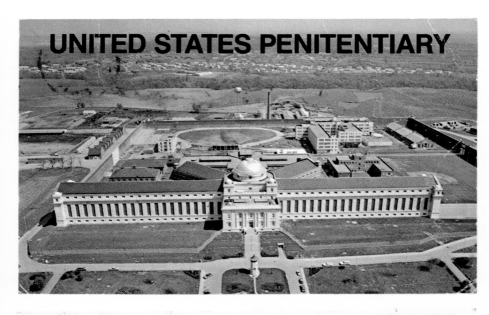

United States Penitentiary.
LEAVENWORTH, KANSAS.

The best known of Federal penal institutions is used to confine the older, more professional type of offender. The main building contains cell space for 2000 prisoners. It is not possible to tour this facility.

Feels like the
Slammer
here —
Love, Whndu

Photo by Leavenworth Chamber of Commerce

031077

Philip Mazzei Patriot Remembered
U.S. airmail 40c

POST CARD

Robert + June Frank
Mabou Coal Mines
Cafe Breton
Nova Scotia
Canada

Par...

d

So I finally gave up but
didn't stop feeling guilty.
Then when you came to AFI
for the retrospective I got
you a bottle of Cow...
as or whatever it was
ff to like.

Do you remember
went to the Watergate
"Candy Mountain" for a
Some man with a long
Cape was following y

Speaking of rememb
do you remember sitt
your house at NSB u
+ me, + saying, "the bad
these things [Seminars] is that
you the illusion of makin
I vowed to myself
moment that we !

be friends. I felt so intense
about that and, despite
so much inaction, always
have. You and I are vastly
different in some ways.
And there were moments when
you weren't at all nice to
me. But there was a
link. A connection that doesn't
fall into any of the conven-
tional categories and which
has always been on the
short list of things that
sustain me.

Thank you.
Send postcards!
Susan

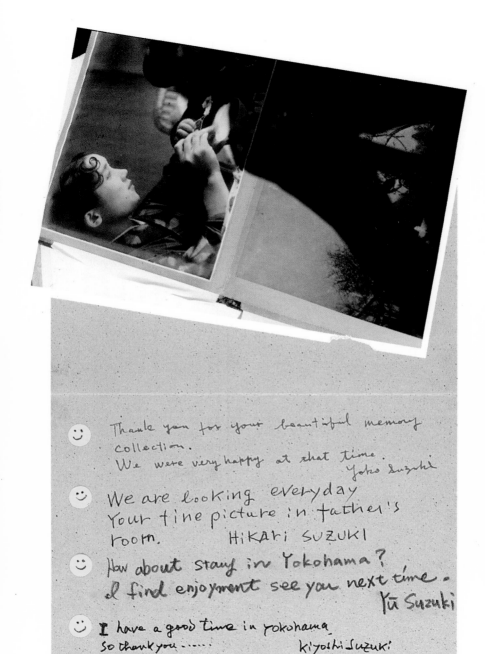

:) Thank you for your beautiful memory
 collection.
 We were very happy at that time.
 Yoko Suzuki

:) We are looking everyday
 Your fine picture in father's
 room. HIKARI SUZUKI

:) How about stay in Yokohama?
 I find enjoyment see you next time.
 Yū Suzuki

:) I have a good time in Yokohama
 so thank you...... Kiyoshi Suzuki

I have saved these cards over many years
I was touched how many people wanted to tell me
their appreciation of what I was doing
without asking anything in return
This small book is my way of saying Thank You

Robert Frank

All net proceeds from the sale of this book will be donated to
the Andrea Frank Foundation, Inc., a charitable foundation
which supports artists and the visual arts.

Robert Frank – Thank You
Cover / Inside Cover by Robert Frank
For the 10th anniversary of Pace MacGill:
Dear Peter—Always wanted to meet
the old Steglitz—I am amazed that
he is coming to the show—Thanks Robert
Edited with Ed Grazda
Design: Hans Werner Holzwarth, Berlin
Production Coordinator: Roland Läuchli
Color seperations: Winster Lithografie, Berlin
Production: Steidl, Göttingen

© 1996 for texts and photographs: the authors
© 1996 for the cover image: Robert Frank
© 1996 for this edition: Scalo Zurich – Berlin – New York
Head Office: Weinbergstrasse 22a, CH-8001 Zurich / Switzerland,
phone 41 1 261 0910, fax 41 1 261 9262
Distributetd in North America by D.A.P., New York City;
in Europe and Asia by Thames and Hudson, London;
in Germany / Austria / Switzerland by Scalo.

Second Scalo Edition 1998
ISBN 3-931141-27-6
Printed in Germany